BODYLINES

THE HUMAN FIGURE IN ART

Felicity Woolf and Michael Cassin
National Gallery Education Department

This book arises from an exhibition mounted by the Education Department in 1987, although it is independent of the exhibition and is not primarily a catalogue.

It is divided into two parts, each of which consists of an introductory essay and a picture section of about ten paintings. Each plate is accompanied by an explanatory text. Part I is concerned with how artists use pre-existing patterns and models, including life-models, when they paint the figure. Part II shows how the human figure is used for expressive purposes in paintings and includes a brief survey of different types of ideal beauty.

C O N T E N T S

FOREWORD

This book relates to the third exhibition in a series devised and created by the Gallery's Education Department. Each exhibition has examined one particular facet of the art of painting, the first dealing with perspective and the second with colour. This third looks at some of the ways in which the human body is described and employed by artists from the thirteenth to the nineteenth centuries.

It is only a few years since the English Press thought it important to devote space to a discussion on the comparative values of abstract and figurative art. Virtually overnight, the work of some American abstractionists came to be no longer inventive or adventurous, but barren and alienated from man and society. In the wake of this re-assessment, the past fifteen years have seen a new development of figurative painting, and consequently this exhibition and book, which deal with one part of the figurative tradition, are timely.

In their discussion, Michael Cassin and Felicity Woolf introduce various concepts relating to the human figure in art. In doing so, they have been guided by their everyday work in the Gallery where they meet the public face to face. As a consequence of these encounters they have directed their book and exhibition to those visitors who have received little or no formal training in art history – in other words, to the majority of the viewing public. To this group, they take care to address that central fact of the visual arts, which tends to annul the abstract/figurative dichotomy – that is, that when an artist paints the human figure he makes use of 'a certain idea'. In other words, even figurative artists employ an abstraction.

This exhibition, although mainly composed of paintings from the Gallery, would have had to take a severely curtailed form but for the generosity of the lenders named on page 47, to whom the Gallery and its public are therefore greatly indebted. To the organisers, Michael Cassin and Felicity Woolf, who undertook this work as an addition to their normally over-full programme, we are all grateful.

Alistair Smith
Keeper, Exhibitions and Education
March 1987

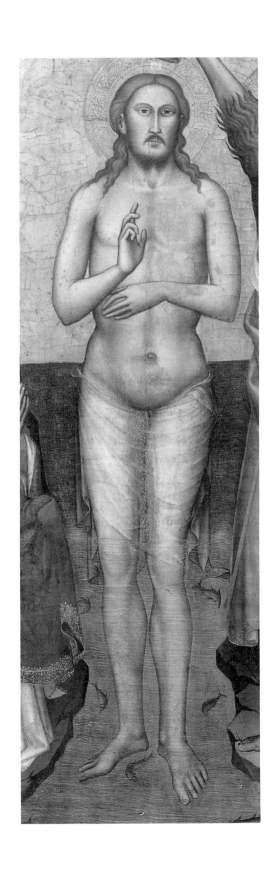

PART I

ARTISTS
AND MODELS

Introduction

We sometimes talk about a 'realistic' painting, as if the picture were somehow alive. It isn't, of course – paintings are flat surfaces, made up of lines and colours arranged in such a way that we may be able to read them as transcriptions of the world we live in.

Learning how to make lines and colours create a convincing likeness of the human figure is a complex process. Anyone who is untrained as an artist knows how difficult it is to draw a complicated three-dimensional solid, such as the body, on a flat surface. Even without training, however, we might find it possible to copy a drawing or a painting of a figure made by another artist. Having done this a number of times, and having learned to expect a particular set of proportions and shapes, we might feel more confident about moving on to draw a living model.

When we come to look at the real thing, we might discover two factors about our processes of visual perception. On the one hand, we would probably be able to recognise the structures and proportions we had learned from copying drawings of the body, and would be able to make a reasonable attempt at drawing the live model. On the other hand, we no longer possess an 'innocent eye'; we see the live model in the light of our experience of copying, rather than as it actually is. We are, in a sense, visually trapped. This connection between art and visual perception has most recently been explored by E. H. Gombrich in his book *Art and Illusion* (1977). Gombrich suggests that there is a never-ending link between art and object – that we see what we know from representations, just as we can only represent what we know.

Traditionally, artists' training accepted this truism about visual experience. First, students copied drawings or paintings, and only then were they allowed to draw three-dimensional objects, sculpture or the live model. In some periods in history, it was not thought necessary to study three-dimensional models at all; training from drawings or paintings was considered adequate.

It is the purpose of this essay to discuss the use of two- and three-dimensional models by a number of figure painters from the thirteenth to the nineteenth centuries. In looking at these

examples, we will also note how occasionally an artist is able to break out of the 'visual trap' and make alterations to the pattern or schema for representing the human body.

Pattern Books

When we look at the *Crucifix*, ascribed to the Master of San Francesco (Plate I), we can see that the male body has been divided into a set of basic sections – head, arms and upper chest, rib-cage, stomach, hips, lower stomach, and legs and feet. These sections are distinguished almost diagrammatically with clear outlines. They are related to our knowledge of the male body in such a way that the image may be easily read as a man on a cross, although we would not describe this as a life-like representation. The painting functioned as a religious icon in a society – mediaeval Italy – which did not place a very great value on realistic painting. That is to say, it was not considered important that an artist should be able to make figures appear fully rounded or realistically structured, with an accurate representation of the bones and muscles beneath the skin.

It seems reasonable to assume that the artist did not need a live model to paint this picture of Christ. He would have learned to divide up the body into schematic sections from earlier paintings. The way the sections are combined into the graceful C-shaped curve may, however, have been an inventive adaptation by the artist, which changed earlier patterns.

We know little about the working methods and training of artists as early as the thirteenth century, when the *Crucifix* was painted. A treatise does, however, survive from the fifteenth century, which describes artists' training and techniques in Italy. These methods can be traced back at least to the beginning of the fourteenth century, to the practice of Giotto and his workshop. The treatise, *Il Libro dell'Arte*, a book of practical advice for aspiring painters, was written by the artist Cennino Cennini. In it Cennino states that the first skill an artist needs is the ability to draw.

Learning to draw in Cennino's system means copying the best works by other artists. It does not, initially, mean drawing

from nature. The student may have to copy frescoes in dark churches, or, as an apprentice in a workshop, he may be able to copy designs from his master's pattern book. Pattern books were collections of drawings, which recorded both finished works and initial ideas for compositions and single figures. Apprentices learned the master's style from continually copying from the pattern book. This was also a way of maintaining consistency when several assistants were involved in making one work. Apprentices' copies have rarely survived, for as Cennino explains, they were often made on a surface of ground bone on a wooden tablet. This surface would be scraped down frequently and renewed.

It is highly likely that the anonymous artist of the *Crucifix* was trained in a similar way to that described by Cennino. He must have made copies from other crucifixes, and from a pattern book kept in a master's workshop. As an independent master he would have built up his own reservoir of designs.

The pattern book system meant that the conventions by which artists depicted figures (or anything else) tended to remain the same for long periods. Patrons demanded that new paintings should look like already existing works. They valued tradition rather than novelty or originality in the modern sense.

Despite the essential conservatism of this system, which means using a pre-decided formula or schema to depict the human figure, every so often an artist is able to make an alteration to the schema, and create a slightly new pattern. Giotto (1266?-1337) was such an artist; he showed how it was possible to make painted figures look more life-like than they did when artists used the Byzantine formula, represented by Plate 1.

We can gain some idea of the changes Giotto made to the schema if we look at the figure of Christ in *The Baptism*, ascribed to Niccolò di Pietro Gerini (Plate 2). Niccolò was trained in Florence in the second half of the fourteenth century. The designs in pattern books and the finished works which he copied as an apprentice would have reflected some of Giotto's innovations. In comparison with the C-shaped Christ in the earlier *Crucifix*, Niccolò's figure appears more rounded and solid, and there is a less obvious divi-

sion between each 'section' of the body; the knees, elbows and ankles are also more clearly articulated. Nevertheless, the figure still does not look entirely life-like; most men do not have such a marked waist.

The Antique and Gothic Patterns

One of the most important principles of Renaissance art theory, was that painting and sculpture should be a realistic, although idealised, reflection of the world. This idea is explored, for example, in a treatise on painting, *Della Pittura*, written in Italy in the 1430s by Leon Battista Alberti. It is not surprising, therefore, that several Italian artists in the fifteenth century made changes to the conventions of drawing and painting the figure, so that the people in their paintings appeared more true to life.

If we look at *Saint Michael* by Piero della Francesca (Plate 3), painted around 1465, we can see that the shape of the figure has changed towards greater verisimilitude or truth to life. In general the saint is stronger and stockier than Christ in *The Baptism*. His arms and legs are thicker and less elongated in proportion to his body. The shape of the torso is also different. There is a division into sections, but the hips and pelvic muscles are emphasised and the waist is less marked. The artist has painted more shadows, which fall to the left, and this also helps to create the impression of a realistic three-dimensional figure.

To arrive at this way of painting the male body, Piero had looked at a new model – antique Roman sculpture. Looking at antique remains was, of course, only one aspect of the revival of interest in classical culture in fifteenth-century Italy. Ancient Roman artists had been expert at making figures which appear true to life, which is one important reason why their sculpture appealed to Renaissance patrons and artists.

If you compare *Saint Michael* with the Roman sculpture of *Youthful Pan* (Fig. 11), made in the first century B.C., you can see that the two artists have represented the male form in similar ways. The overall proportions are comparable, as is the division of the torsos, and the emphasis on the pelvic muscles. The figures stand in the same pose, with the weight on one leg, the free leg

slightly bent and the hips tilted. During the Renaissance this pose became known as 'contrapposto'. It creates interesting asymmetry in the body and also suggests movement. By the end of the fifteenth century most Italian artists had adopted this antique pattern for the depiction of the male body.

In Northern Europe, however, an artist working about thirty years after Piero, used a very different pattern when painting figures. *Saints Peter and Dorothy* (Plate 4), painted in Cologne in about 1500, reflect the shapes of German gothic sculptures, as can be seen by comparing them with *Saint Sebastian* and *Saint Ursula* (Figs. 12 and 10). If Saint Peter undressed, his body would be divided clearly at the waist, below a prominent rib-cage; he would not have the heroic muscular body of an antique sculpture or of Piero's *Saint Michael*. Saint Dorothy has a small waist and tiny high breasts like the sculpture of *Saint Ursula*. This is a very different shape from the more solidly built and more evenly proportioned antique female type, represented, for example, by a statue of *Venus* (Fig. 9), from the first or second century A.D. The classical female form had also begun to influence Italian artists during the Renaissance, as is discussed in Part II.

Like his Italian contemporaries, the anonymous artist of *Saints Peter and Dorothy*, usually known as the Master of the Saint Bartholomew Altarpiece, would have learned to paint figures by copying drawings and paintings, but these models had evolved separately from the Italian tradition. The pattern book designs and the finished works which would have been most influential for this artist would have derived ultimately from the work of the Netherlandish artist Rogier van der Weyden (about 1399-1464).

Soon after this panel was painted, as is discussed in Part II, Northern artists became aware of the antique pattern, and gradually they made changes to the traditional gothic schema.

Life- and Anatomical Drawings

In Italy, in addition to looking at classical statues, artists also started to study and draw the live model, in order to make their paintings truer to life. What is interesting is the way that the inanimate

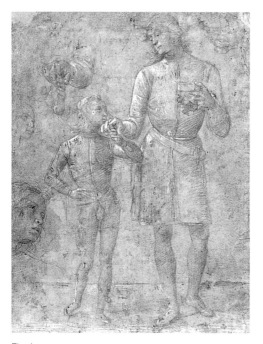

Fig. 1
Pietro Perugino
Studies for Tobias and the Angel
Silverpoint, heightened with body colour, (partially oxidized)
23.8 × 18.3 cm
About 1500
Oxford, Ashmolean Museum (Parker Vol. II, no. 27)

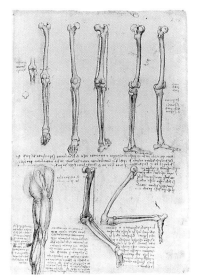

recto

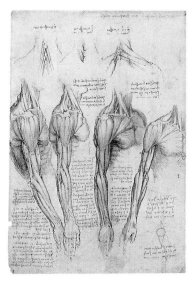

verso

Fig. 2
Leonardo da Vinci
Anatomical drawing
Recto: pen and brown ink with wash modelling over
traces of black chalk; verso: pen and brown ink with
wash modelling over traces of black chalk, with small
red chalk strokes between the main figures
28.8 × 20.7 cm
About 1510
Windsor Castle, Royal Library (Inv. no. 19008, recto
and verso)

model – the antique relief or free-standing sculpture – influenced the artist's eye when he was looking at a living model. Models were often apprentices or assistants who posed in the workshop, either nude or in contemporary clothes. In a drawing by Pietro Perugino (Fig. 1), on a sheet of studies for *Saint Raphael and Tobias* (Plate 5), the assistants stand in their everyday clothes in a 'contrapposto' pose, similar to the *Youthful Pan* (Fig. 11). It is clear from other Italian Renaissance life-drawings that not only the poses, but the proportions of antique sculptures were 'seen' in the life-models. It seems unlikely that fifteenth and sixteenth-century workshop assistants were as muscular and perfectly formed as the drawings of them sometimes suggest!

Renaissance painters, not unreasonably, supposed that they would be better equipped to paint accurate pictures of the human body if they were more aware of how it worked. As a result, in an attempt to discover how the bones and muscles of the body affect its surface, the interest in drawing from life was accompanied by a corresponding interest in drawing the anatomy of dissected corpses.

The dissection of human bodies was, of course, frowned upon by the Church. Nevertheless, a number of artists of the fifteenth century are known to have attended dissections, even if they did not actually do the cutting themselves. The most famous group of anatomical drawings of this period are those executed by Leonardo, probably from the dissection of an old man. These drawings, such as Fig. 2, show the depth of Leonardo's interest in the subject, and a dazzling technical skill.

If we look at an altarpiece (Plate 6) painted in 1485 by a contemporary of Leonardo, Filippino Lippi, we can see clearly that Lippi had acquired the knowledge of anatomy needed to paint the bare shoulder and arm of Saint Jerome, on the left, with convincing verisimilitude. The complex system of bones, muscles and sinews beneath the surface is indicated. The artist perhaps made a life drawing of an old man, and at some stage must certainly have made or studied anatomical drawings of this part of the body. When painting the figures of Saint Dominic and the Virgin,

however, the artist seems not to have referred to life-drawings or anatomical studies, but to have used older, more traditional schemas.

From Workshop to Academy

By the end of the sixteenth century the activities of drawing antique sculptures, life-drawing, and making or copying anatomical drawings, had become an accepted part of artists' training, as is clear from numerous drawings and prints. Hendrik Goltzius (1558-1617) worked in Haarlem; his engraving of a famous antique, the *Apollo Belvedere* (Fig. 3), suggests that if Dutch artists could see neither the original in Rome, nor a cast, they could copy a print to study the pose and proportions of the statue. In an early seventeenth-century etching by Pierfrancesco Alberti (Fig. 4), a number of students are shown dissecting a corpse in a disturbingly unsubtle way on the right, while others draw from skeletons and casts of the antique. It is difficult to believe that these activities actually took place in the same room, as the print implies. It is more likely that the artist has grouped them together to show the variety of exercises a student would have to master during his training.

During the sixteenth century training remained within the informal structure of the master's workshop. However, from the beginning of the seventeenth century formal academies started to be established in several European cities. They institutionalised artists' training and gradually broke down the old apprenticeship system. Artists learned the skills of their trade in the academies rather than in the workshop of an established master. It may be that the drawing of a life class by the Italian artist Canini (1617-1666) shows a seventeenth-century academy (Fig. 5). Young artists sit in rows drawing the model who kneels on a trestle table, supporting himself in the pose with props. A lamp hanging on the right provides consistent lighting to emphasise the anatomy of the model.

In England the Royal Academy was founded in 1768. The curriculum included drawing from casts of the most famous

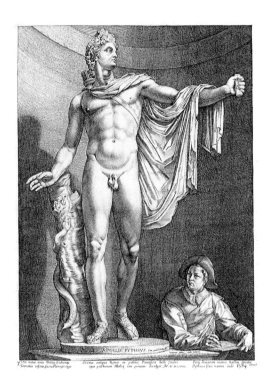

Fig. 3
Hendrik Goltzius
Apollo Belvedere
Engraving from *Antique Statues in Rome*
40.2 × 29.2 cm
About 1592, dated 1617
London, British Museum, Department of Prints and Drawings (Inv. no. 1854-5-13-106)

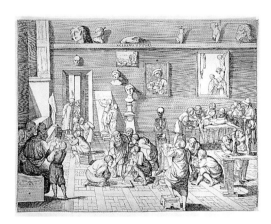

Fig. 4
Pierfrancesco Alberti
The Academy of Painters
Etching, 41.1 × 52.4 cm, early seventeenth century
London, British Museum, Department of Prints and
Drawings (Bartsch XXXVIII 313-1)

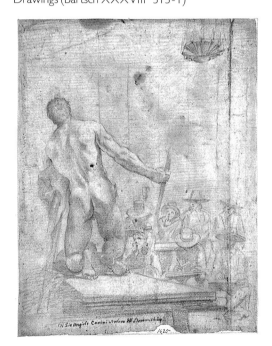

Fig. 5
Giovanni Angelo Canini
Life Class in an Academy
Red chalk, 30.9 × 24 cm, mid-seventeenth century
London, British Museum, Department of Prints and
Drawings (Inv. no. 1946-7-13-708)

antique sculptures, and attending the life class, which is illustrated in
the print by Rowlandson and Pugin (Fig. 6). The model is placed as
in the Canini drawing, on a raised platform, and is similarly
illuminated from one direction, although more elaborately, to
emphasise the forms of the body. The room, however, is much
larger and the semi-circular seating more formal and permanent.

Students also attended lectures on the structure and work-
ings of the human body, which were given by the Academy's own
Professor of Anatomy. To avoid the necessity for repeated
dissections, *écorchés* were used as teaching aids. *Écorchés* (flayed
figures) are casts made of wax or plaster taken from bodies which
have been flayed so that the muscles are visible.

The *écorché* known as *Smugglerius* was made from the body
of a man executed, as its name suggests, for smuggling. The Royal
Academy owns a nineteenth-century version of the original cast,
which was made in 1775 (Fig. 7). Even here, we can still see the
influence of the antique; the smuggler's body has been cast in the
pose of an antique sculpture known as the *Dying Gaul*.

The first President of the Royal Academy was Sir Joshua
Reynolds. From his paintings and his writings we know a great deal
about his practice as an artist. Reynolds was totally committed to
the system of teaching carried out at the Royal Academy schools.
He himself copied old master paintings, drew antique sculptures
and casts, and used life-models. Not surprisingly, his paintings, the
majority of which are portraits, reflect the triumph of the classical
model.

When we first look, for example, at the portrait of the
soldier, General Sir Banastre Tarleton (Plate 7), who fought in the
American War of Independence, we can easily be convinced that
the artist positioned a live model in a pose which simply suggested
action on the battlefield. In fact, Reynolds based the pose on a
well-known classical sculpture of the Roman Republican hero
Cincinnatus, who left rural retirement to fight for his country
(Fig. 8). Through the use of this model, Reynolds transferred to
Tarleton the general notion of the nobility of antique culture, and
the specific heroism of Cincinnatus.

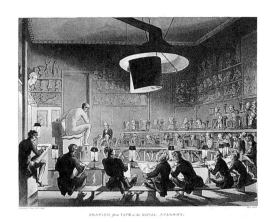

Fig. 6
Thomas Rowlandson and Augustus Pugin
The Life Class at the Royal Academy
Coloured aquatint from *The Microcosm of London*, I,
plate 1
19.5 × 25.6 cm
Volume dated 1808
London, British Museum, Department of Prints and
Drawings (Inv. no. 1856-7-12-685)

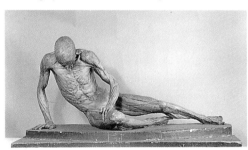

Fig. 7
W. Pink (after Agostino Carlini)
Écorché-Smugglerius
Plaster cast, length 148.6 cm
About 1834
London, The Royal Academy of Arts

The End of the Academies

During the nineteenth century some artists began to find the rigid discipline of academic training too restricting. Models were only posed in a limited range of positions, based on antiquities, and a degree of spontaneity could be lost in the process of squaring up drawings for transfer to a larger scale, before painting the figures in a precise and carefully worked technique in a large composition. We can, perhaps, sense an element of impatience in an *'Académie'* (Plate 8), a painting of the nude ascribed to Géricault. The unfinished hand at the top right reveals that in the first layers, at least, the artist favoured a rather free, broad application of paint, which must have appeared rather undisciplined at the time.

Gradually, the supremacy of the classical model also came to be challenged. Edgar Degas, like Géricault, was trained in the academy system, but used new patterns on which to base his exploration of the subject matter of modern life. The pastel of a *Woman Drying Herself* (Plate 9) belongs to the tradition of life-drawing, but Degas preserves the ungainly posture of the model, and is able to represent the woman's proportions without 'seeing' them via an antique model – she has a long back and fleshy stomach and hips.

Degas was probably able to set new poses and perceive natural proportions in his models partly with the help of photography, for which he was an early enthusiast. The camera could be an 'innocent' eye and reveal fresh views of the figure, so enabling the artist to escape the visual trap of his traditional training.

Freed from the requirement that painting should be realistic, some artists in the twentieth century further extended the patterns available for representing the human figure. With his use of multiple viewpoints and the breakdown of the figure into a set of shorthand symbols, Picasso in a sense looks back to the schematisation of mediaeval artists, such as the painter of the *Crucifix* (Plate 1). Picasso also copied and adapted a new set of schema, which he saw in imported African sculpture. Of course, in time, Picasso's inventive changes to the schema for representing the human figure, became established as patterns which have

frequently been used by other modern artists.

As a postscript, we may note that life-drawing is still taught on many art training courses. While most contemporary painters would acknowledge that it is good training, they would not perceive it as an essential skill.

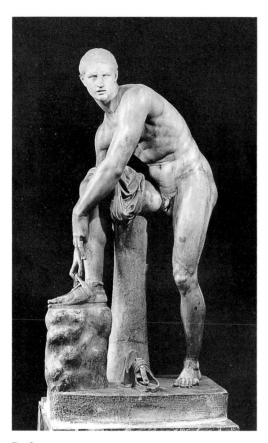

Fig. 8
Cincinnatus
Marble, height 154 cm
Roman copy of a bronze original of the
early third century B.C.
Paris, Louvre

The figure of Christ has clearly not been drawn from a live model. The body has been divided into several sections, which bear some relationship to the viewer's knowledge of the male body, although we would not describe the representation of these sections as life-like.

It is possible that this way of schematising the body was borrowed by mediaeval Italian artists from Byzantine art. The anonymous painter of this crucifix, seems to have been a highly inventive artist who adapted the Byzantine pattern into the C-shaped curve we see here. The strong line from the right shoulder, curving down to the stomach and following the inner line of Christ's left leg produces the impression that the body is weighty and pulls away from the Cross.

This crucifix was made in Umbria, in central Italy, at the end of the thirteenth century. It was probably made to be carried in religious processions, and this may partly explain why the figure of Christ is comparatively large and dominating. Christ's head is silhouetted against a halo which is raised from the wooden support. His body is outlined with dark lines, and the blood from His wounds is prominently painted. Christ's dominance is also emphasised by the much smaller scale mourners at His sides. This element of story-telling – the reactions of others beneath the Cross – is less important than the function of the crucifix as an icon, or symbolic pictorial object.

The circle above Christ's head is now filled with resin, made in the nineteenth century. Originally this was a cavity, which may have held relics. When the cross was not being carried in processions, it may have stood on an altar table, and functioned as a reliquary.

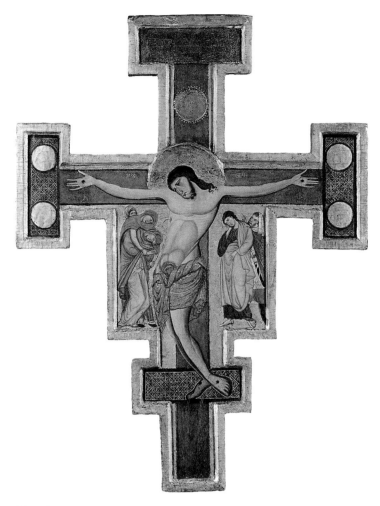

Plate I
Ascribed to the **Master of San Francesco** Active late 13th century
Crucifix
Tempera on wood, 92.1 × 75 cm

The schema or pattern used by this artist in his representation of the male body is different from that used by the painter of the *Crucifix* (Plate 1). The artist has made the figure of Christ appear more realistic; it is more three-dimensional, and less obviously divided into sections. There is more indication of the structure beneath the skin, for example at the knees and ankles. The artist has used the conventions of modelling, shading from dark to light, to create an impression of volume. Although the figure appears to be nearer to our knowledge of the male body, it is still not entirely true to life. The artist certainly did not use a life-model; the marked waist makes the lower part of the torso appear like a woman's waist and hips. Although the hips are level, one leg appears slightly longer than the other.

The identity of the artist is uncertain, but the painting is generally ascribed to a Florentine artist, Niccolò di Pietro Gerini, active in the second half of the fourteenth century. The artist would have learned how to represent figures from studying the designs of his master, in finished works and in a workshop pattern book.

Niccolò's master was probably Andrea Orcagna or an artist from his circle. Orcagna was the dominant artist in Florence in the last quarter of the fourteenth century. Ultimately his way of painting the figure derives from Giotto, who was probably responsible for the major changes in representation visible when comparing Christ in *The Baptism* with Christ in the *Crucifix* (Plate 1).

The painting was probably the altarpiece of a chapel finished in 1387 and dedicated to Saint John the Baptist in the monastery church of Santa Maria degli Angeli in Florence.

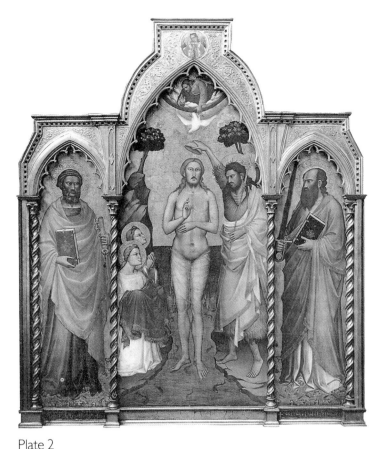

Plate 2

Ascribed to **Niccolò di Pietro Gerini** Active 1368, died 1415

The Baptism of Christ, with Saints Peter and Paul

Tempera on wood

Central panel 160 × 76.2 cm, side panels 123.2 × 36.8 cm

The overall proportions and the shape of the torso are different from those of Christ in *The Baptism* (Plate 2). The pelvic area is larger, and the waist is higher and less prominent. The figure is less elongated and more athletic. This schema derives from that used by antique artists, as can be seen by comparing *Saint Michael* with the *Youthful Pan* (Fig. 11). In both figures the division of the torso is similar, as is the pose with the weight distributed unevenly. This schema was revived by artists in Italy at the beginning of the fifteenth century. Piero della Francesca continued the revival, and perhaps it was antique models that helped him to create intensely solemn figures.

Despite the use of conventions which convince us of the verisimilitude of the figure, such as the consistent lighting from the right, which casts shadows to the left, it is not necessary to suppose that Piero used drawings of a live model to create this figure. The proportions of the figure, generally based on those of antique sculpture, may also relate to a Renaissance theory of proportion, such as that described by Alberti in his treatise on sculpture, *De Statua*, which divides the height of the figure into six equal sections.

This panel was once part of an altarpiece, completed in 1469, for the church of San Agostino in San Sepolcro. The altarpiece showed the Virgin Mary enthroned, with two saints standing on either side of her. The edge of the Virgin's robe can be seen near Saint Michael's feet, showing that he originally stood to the left of her throne. The saint stands on the body of a snake, whose head he holds. The snake represents the devil, over whom Saint Michael was victorious.

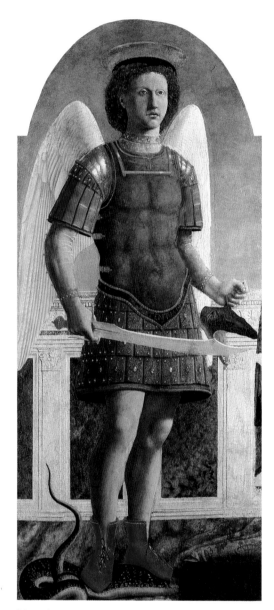

Plate 3
Piero della Francesca
Active 1439, died 1492
Saint Michael
Oil on wood, 133 × 59.4 cm

Until about the end of the fifteenth century Northern European artists perceived and represented the shape of the male and female figure in a way which was quite different from that of Italian painters. If we compare Saint Peter with Piero's *Saint Michael* (Plate 3) or with the *Youthful Pan* (Fig. 11), we can see that there is no attempt to give Saint Peter the structure, proportions or pose of an antique statue. His drapery is not arranged to reveal the forms of his body, but for decorative effect. Similarly, the shape of Saint Dorothy bears no resemblance to that of an antique *Venus* (Fig. 9); she has a small, high waist, and swelling abdomen and hips. These male and female types, which emphasise human weakness and earthly existence, are based on the gothic schemas which developed through the Middle Ages in sculpture (Figs. 10 and 12), in manuscript illuminations and finally in panel painting. In painting, the types were established in the mid-fifteenth century by Rogier van der Weyden, who worked mainly in Brussels.

It would be inaccurate, however, to suggest that the two saints are painted unrealistically. We can see that the anonymous artist of this panel was as expert as his Italian contemporaries at making his painting look, as Alberti put it in *Della Pittura*, like a window on the world. There is a convincing impression of space and natural light, and many different textures – marble, stone, cloth, brocade, hair – are represented with considerable virtuosity. It is simply a matter of different expectations on the part of both the artist and the viewer of the conventions of representing the human figure.

Although he was probably trained in the Netherlands, this anonymous artist worked mainly in Cologne. He is named after the central panel of an altarpiece which shows Saint Bartholomew. The National Gallery panel may be part of one of the wings of that altarpiece, which was made in about 1500 for the church of Saint Columba in Cologne.

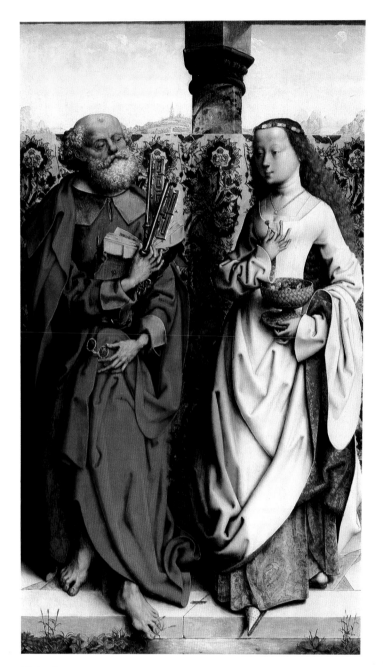

Plate 4

Master of the Saint Bartholomew Altarpiece

Active late 15th/early 16th century

Saints Peter and Dorothy

Oil on panel, 125.7 × 71.1 cm

A drawing (Fig. 1), now in Oxford, shows that the artist used two studio assistants as models for the archangel Raphael and Tobias. However, like Piero della Francesca, and, as is characteristic of late fifteenth-century Italian artistic practice, Perugino had another model in mind when making this painting. He directed the assistants to stand in the pose of many antique statues and reliefs (and of Piero's *Saint Michael*, Plate 3), with the weight on one leg, moving one hip upwards. Although the angel's drapery conceals this 'contrapposto' stance to some extent, both figures have adopted it.

Despite his adoption of the new antique schema, Perugino had been trained in, and perpetuated the pattern book tradition. He invented a limited range of designs, and the figures in his paintings tend to stand in similar, two-dimensional poses, and to share the rather bland facial type we can see here. The workshop pattern book must have served as a record of these figure types.

This panel depicts the archangel Raphael and the boy Tobias, who Raphael helped on a journey to claim money for his father. It was originally part of an altarpiece made for the abbey church at Pavia, near Milan. The altarpiece had six sections arranged in two rows. All three panels from the lower level are now in the National Gallery. The *Raphael* panel is from the lower right hand corner. It has been cut down at the bottom, as can be seen from the loss of the body of Tobias' dog.

The altarpiece was probably commissioned in the 1490s by Ludovico Sforza, Duke of Milan. Documents suggest that progress was slow, and the upper register remained unfinished at Perugino's death in 1523.

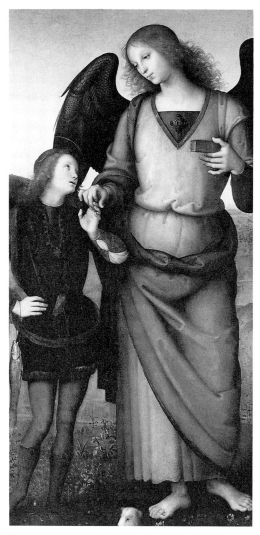

Plate 5

Pietro Perugino Living 1469, died 1523
Saint Raphael and Tobias
Oil on wood, 126.4 × 57.8 cm

Filippino Lippi was a contemporary of Perugino and his training and artistic concerns would have been essentially similar. He worked at a time when Italian artists had completely absorbed the antique model as a way of representing the figure, although late fifteenth-century Florentine taste was for rather lighter, prettier figures than those, for example, of Piero della Francesca (Plate 3). Some of Filippino's figures are as predictable as Perugino's. In this altarpiece the Virgin and Child and Saint Dominic, kneeling on the right, are probably standard figures from the studio pattern book. On the other hand, Filippino seems to have been more deeply interested in naturalism than Perugino. For example, although Saint Jerome, on the left, may also have been taken from a pattern book, it is clear that at some stage the artist had studied what happens underneath the skin — he has represented the bone and muscle structure of the arm, shoulder, neck and chest with considerable accuracy.

In their concern for verisimilitude, several Italian artists working in the later part of the fifteenth century made anatomical drawings from human dissections. Filippino may have made such drawings himself, either from a corpse, or from another artist's drawings.

This altarpiece was commissioned by the Rucellai family for a chapel in the church of San Pancrazio in Florence. It was finished in about 1485. The background landscape contains tiny figures and animals, which illustrate the legends associated with the saints in the foreground.

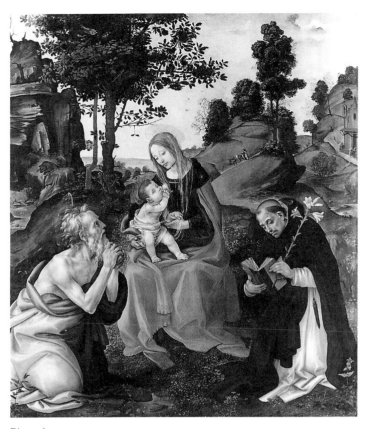

Plate 6

Filippino Lippi 1457(?) – 1504

The Virgin and Child with Saints Jerome and Dominic

Oil on wood, 203.2 × 186.1 cm

This portrait epitomises the painting methods taught and perpetuated by European academies in the seventeenth and eighteenth centuries. The soldier stands, apparently spontaneously as if in battle. In fact, he is in the pose (in reverse) of an antique sculpture (Fig. 8). The sculpture was believed to be of Cincinnatus, a Roman Republican hero who left retirement to fight for his country. The sculpture was well known in England from casts, one of which was owned by the Royal Academy schools. The face is presumably a good likeness, but the proportions of the figure would have been 'corrected' according to the sculpture.

While fighting in the American War of Independence, Tarleton (1754 – 1833) lost some fingers from his right hand. In the painting this disfigurement is disguised by the position of his hand. The gesture is taken from the sculpture, in which the figure fastens his sandal. The reference to Cincinnatus would have been 'read' easily by an educated eighteenth-century viewer. It gives Tarleton both the physical idealisation of the statue and the qualities of a patriotic and brave antique hero.

The painting was commissioned in 1782, after Tarleton's return to England. Some nine sittings are recorded in Reynolds' pocket-book. There may also have been one 'sitting' for Tarleton's horse. The portrait was exhibited in the same year at the Royal Academy exhibition as *Portrait of an Officer*.

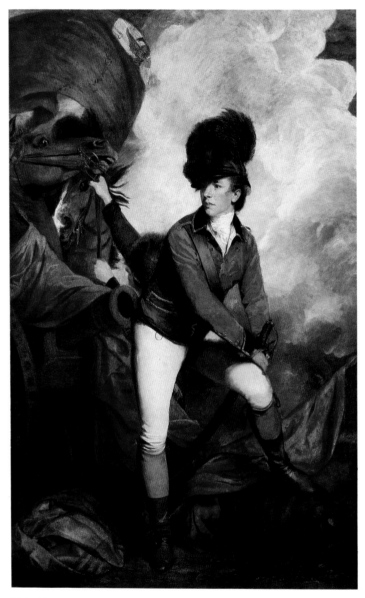

Plate 7
Sir Joshua Reynolds　1723 – 1792
General Sir Banastre Tarleton
Oil on canvas, 236.2 × 145.4 cm

An 'académie' is a painting of the nude done as an exercise by students in art schools. The figure may be worked up from drawings, or painted directly from the model.

This example is unfinished. It is painted in relatively broad brushstrokes with few details, and maintains an unusual degree of spontaneity. The pose of the model would have been set by the master in the life-class, and would often have been similar to the pose of a famous antique sculpture. Here, the raised arm is reminiscent of an antique known as the *Borghese Warrior*. The painted figure leans forward less than the statue but the torso is twisted in the same way and the arrangement of the arms and legs is similar.

Although 'académies' were only exercises, artists often included figures in the same pose in large-scale finished works. It may be significant, therefore, that the pose of this figure, at least from the waist up, is very similar to that of the famous figure who waves to the rescue ship from the top of the heap of bodies in Géricault's masterpiece *The Raft of the Medusa*. Now in the Louvre, *The Raft* was first exhibited in 1819.

Géricault studied with the established masters Carle Vernet and Guérin. Although he soon left the restricting studios of these academic painters, he never abandoned the practice of painting and drawing from the live model. What he did abandon was the use of meticulous preparatory drawings which would be squared up and transferred to canvas. Instead he would draw and paint his models in an almost endless variety of poses until he arrived at a satisfactory composition. Then he would usually paint the final version directly from life.

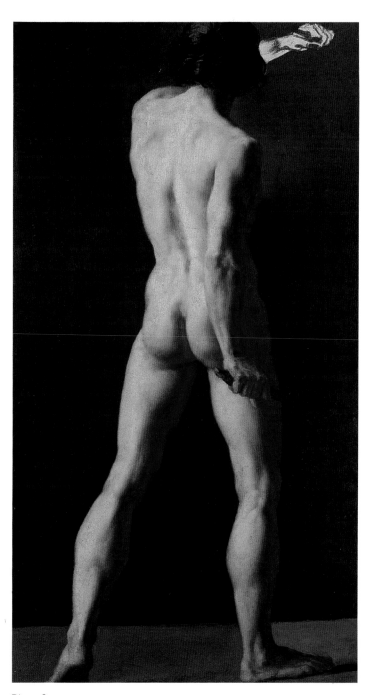

Plate 8
Ascribed to **Théodore Géricault** 1791 – 1824
An 'Académie'
Oil on canvas, 67.3 × 36.8 cm

This is one of a series of large pastel drawings of women bathing and drying themselves, which Degas made in the late 1880s and 1890s. Degas had been trained in the French academic tradition, at the Ecole des Beaux Arts, and this pastel continues the tradition of life-drawing. However, by including objects from a domestic interior – towels and a bath – Degas transformed a study of a life-model into an intimate image of contemporary life, which is far removed from the clinical impersonality of the academic life-class.

The woman has her back to the viewer, and seems unaware of the intrusion. Degas is reported as saying that he wanted to create the impression of spying on the model through a keyhole, presumably meaning that he wanted these images to appear as spontaneous and unposed as possible.

The domestic subject matter and the compositions of the pastels may have been suggested to Degas from his knowledge of Japanese prints. These became available in Paris in the second half of the nineteenth century. In the prints the compositions are often seen from unconventional viewpoints and are sometimes abruptly cropped. Here we see the model from an unexpectedly high vantage point, and the right side of the composition ends without the traditional framing device of Western art.

In his paintings and pastels Degas sometimes reproduced effects which he had learned from the relatively new art of photography. In this example it may be that the camera enabled Degas to perceive the model afresh, without the classical idealisation of the academic tradition. She is represented in a rather ungainly pose and has a long back, with fleshy stomach and hips.

Pastel was an established medium, but Degas explored the expressive possibilities of the chalks in a new way. The woman's back seems soft and sensual, and yet the pastels are applied with bold, almost coarse strokes.

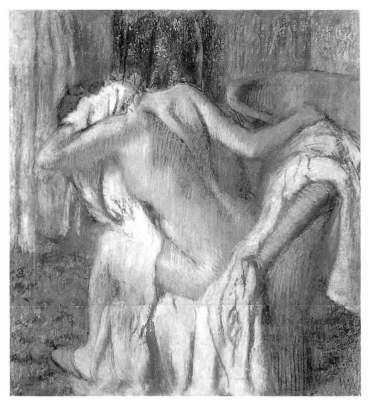

Plate 9
Hilaire-Germain-Edgar Degas 1834 – 1917
Woman Drying Herself
Pastel on paper, 103.8 × 98.4 cm

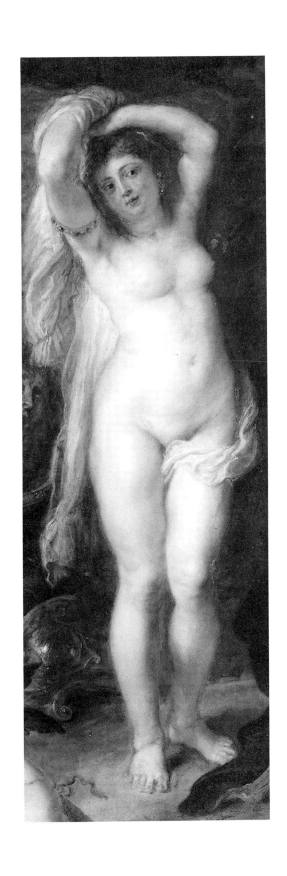

PART II

BEAUTY AND BODY LANGUAGE

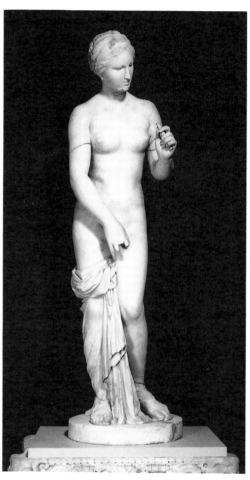

Fig. 9
Venus
Marble, height 104 cm
Roman, first or second century A.D.
London, British Museum, ex-Townley Collection
(Sc. 1577)

Origins

The art of ancient Greece and Rome, a primary source of all Western painting, is described in a book written in the first century A.D. by Gaius Plinius Secundus, better known as Pliny the Elder. The main subject of the book is Natural History but Pliny discusses the work of painters and sculptors in his volume on stones and minerals and their uses.

In one famous passage he describes how the Greek artist Zeuxis was commissioned to paint a picture of Helen of Troy for the Temple of Hera at Croton. The inhabitants of the city sent him their most beautiful maidens so that he could choose the loveliest of them as his model. However, being an experienced painter, Zeuxis realised that no single individual could have the flawless face and perfect proportions of the legendary Helen, so he selected five of the girls and combined their best features to produce his image of the most beautiful woman in the world.

This story was well-known in Italy in the fifteenth century. It was repeated, for example, by Alberti in *Della Pittura*. Artists and historians of the period would have expected Zeuxis' perfect figure to have many of the characteristics of the antique statue of *Venus* (Fig. 9), in the British Museum. This is not a real woman – there are no features which mark it as an individual. Instead it is an imagined, ideal figure whose proportions conform to a pattern established by centuries of tradition. The body is about the same length as the legs, the muscles of the torso are suggested but not over-emphasised, the waist is slim and the breasts and hips are soft and rounded but also taut. The figure stands with her weight on one leg, in a pose which is graceful and relaxed.

The arms of the sculpture were restored in the eighteenth century, but it is likely that the original right arm would have been extended in a similar gesture of modesty. This type of statue is known as a 'Venus pudica' ('pudica' meaning 'chaste' in Latin). The pose was very common, perhaps because it manages to be modest and coy at the same time.

Antique sculptures like this were admired for their perfect beauty and ideal proportions, and these ideals were referred to

by many generations of later artists, as we shall see. However, its gesture is also significant, and we shall also be looking at ways in which later artists, who may have had little or no interest in idealised classical forms, made use of the expressive possibilities of pose and gesture.

The Renaissance

As we have already seen in Part I, Renaissance artists were greatly influenced by the idealised forms of the many fine examples of antique sculpture which were unearthed throughout the fifteenth century. Correggio's work, like the earlier paintings of Piero della Francesca, reflects an enthusiasm for this sculptural ideal of beauty. For example, in the painting popularly known as 'The School of Love' (Plate 10) the pose of the figure of Venus is based on the antique 'Venus pudica' model. The shoulders and breasts are particularly close to the sculpture, while the hips have been exaggerated and enlarged.

In Correggio's time large numbers of similarly idealised female nudes were painted with the title 'Venus'. Many of them were primarily intended for male viewing and undoubtedly meant to be erotic. However, their mythological 'disguise' maintained an acceptable degree of decorum.

In Northern Europe painters and sculptors were steeped in a separate tradition and employed rather different proportions in their figures. We can see this if we compare the antique Venus with the gothic sculpture of Saint Ursula (Fig. 10) made in the Lower Rhineland in the early sixteenth century. The saint is less robust than the antique goddess. She has a narrow, high waist, and small breasts placed high on the chest, and her hips and abdomen are more pronounced.

As more and more Northern artists travelled south and were exposed to the paintings and sculpture of the Italian Renaissance, classical ideals and patterns began to filter back across the Alps. Of course this process was a very gradual one and these new theories did not displace Northern gothic forms overnight.

Albrecht Dürer visited Italy in 1494 and 1505 and returned

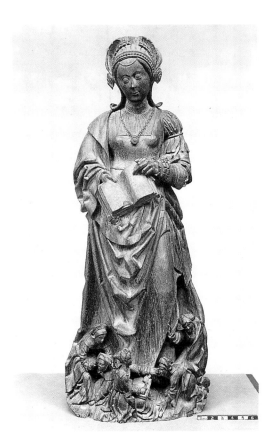

Fig. 10
Master of Elsloo
Saint Ursula
Oak, height 96.5 cm
1510-20
London, Victoria and Albert Museum
(Inv. no. 621-1895)

home with a knowledge of Italian art and an awareness of the geometric formulae used to design images of the human body. However, although he was deeply interested in the mathematics of human proportion, he was never entirely convinced that the figure could be satisfactorily constructed by means of measurements and ratios. He discussed the problem in his *Four Books of Human Proportion*, published in 1528, and eventually came to the conclusion that 'nature is master in such matters'. He went on to say: 'I hold that the perfection of form and beauty is contained in the sum of all men. I would rather follow the man who can extract this aright, than one who wants to establish some newly thought-up proportion, in which human beings have had no share'.

Of course a great many Northern artists never went to Italy. Lucas Cranach, for example, spent much of his life in Wittenberg and his knowledge of classical forms was therefore indirect, second-hand. The female type represented in his painting of *Cupid Complaining to Venus* (Plate 11) may have some of the grace and elegance of an antique nude but clearly it also has many of the traditional gothic characteristics of the statue of Saint Ursula, including the high waist and the small breasts.

The 'Natural' Nude

The theory that there is a perfect set of proportions for the human body, an ideal beauty, is one which continued to fascinate artists and others for centuries, but of course every society has its own ideas about how to define this ideal. In the seventeenth century artists like Rubens were able to combine an interest in the ideal with a desire to paint increasingly natural figures. In his *Judgment of Paris* (Plate 12), the three goddesses competing for the prize of the golden apple, to be awarded to the most beautiful, are based on classical sculptures of Venus, or perhaps of the Three Graces. Yet they are not de-personalised abstractions like the Roman *Venus*. They look more human than divine, and are even slightly ungainly as they display themselves.

It seems likely that these three views of the female form are based on drawings after a live model (possibly Rubens' wife), who,

by our own standards of ideal beauty, was somewhat overweight, if sumptuously so. Rubens managed to give his figures the dignity and authority of classical goddesses, while at the same time including some of the peculiarities which might be found in a living body. As in the Renaissance, the painting functions partly as a source of titillation. These luscious, provocative females know they are being looked at; they are presenting themselves for the delight of the spectator.

In the painting of A Woman Bathing in a Stream (Plate 13) by Rembrandt the figure is perhaps as ungainly as Rubens' goddesses, but the effect is quite different. The subject is not dissimilar: in both paintings female figures are showing more of their bodies than would be thought entirely proper if this were not art, but the goddesses in Rubens' painting know they are being watched, while the woman in Rembrandt's picture seems unaware of being looked at. As a result, the painting is more private, more intimate than the larger, public work by Rubens. It suggests a relationship between artist and model which is more than merely professional, and this intimacy makes the spectactor feel a bit like an intruder or a voyeur.

The Male Ideal

In the ancient world the male figure was also idealised. It was made to conform to a series of abstract proportions, as we might expect if we remember that such figures were often intended to represent Olympian gods or outstanding athletes. The male classical ideal can be seen in the statue of the Youthful Pan (Fig. 11). Unlike the female statue (Fig. 9), this figure is divided not at the waist but at the pelvis, where the muscles which join the torso to the legs form a marked 'V' shape. The figure is shown in contrapposto and is well-built, though not emphatically muscular. The statue conforms to a general type, and, as with the female figure (Fig. 9), any features which would mark it as a unique individual have been deliberately avoided. The figure is harmoniously proportioned, relaxed and comfortable, but also firm and capable of athletic action.

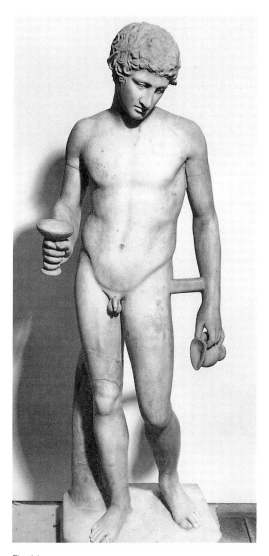

Fig. 11

Marcus Cossutius Cerdo (signed on the support)
Youthful Pan
Marble, height 109 cm
Roman, first century B.C.
London, British Museum, ex-Townley Collection
(Sc. 1666)

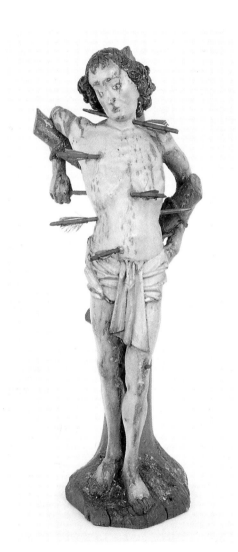

Fig. 12
School of Arnt von Kalkar
Saint Sebastian
Polychromed oak, height 75.5 cm
About 1490, with arrows of a later date
Edinburgh, Royal Museum of Scotland (Chambers
Street) (Inv. no. 1905-847)

In constructing these ideal proportions it is likely that artists made use of the head as a unit of measurement; the statue of Pan, for example, is about six head-heights tall. In Italy during the Renaissance, the proportions of the human figure were sometimes measured in this way. Alberti created a theoretically ideal man, using a different system of proportions, whose height could be divided into six equal parts, which were not based on head-height. Later in the century Leonardo da Vinci suggested a slightly different system. In his notebooks he explained how to construct the perfect human figure by means of a geometrical system in which the head is an eighth part of the total height of the male body.

Just as Correggio's Venus resembles the antique 'Venus pudica' so *Saint Sebastian* (Plate 14) by Cima is very close to the classical type represented by the *Youthful Pan* (Fig. 11). The saint stands in the same pose as the statue, and he has a similar flawless, unindividualised body. However, the proportions used by this Venetian artist are different from those used by his classical predecessor, and nearer to those recommended by Leonardo. *Saint Sebastian* is about eight head-heights tall. He is slimmer than *Pan* and his chest and pelvic muscles are less prominent. The saint is shown as a young man still, almost an adolescent, and his youth emphasises his role as an innocent and defenceless victim.

The Expressive Body

Saint Sebastian became a very popular subject for artists during the Renaissance, as his story allowed them to indulge their interest in the classically proportioned naked body under the pretext of painting a respectable Christian saint.

But classical proportions and idealised figures have not always been thought appropriate in a Christian context. During the Middle Ages, when the Church was anxious to emphasise the need for repentence, the comfortable, confident nude figures of the classical past were thought inappropriate and even shocking. Artists were expected to use the human body as a means of arousing appropriate Christian emotions in a church congregation.

The wooden sculpture of *Saint Sebastian*, from the School of Arnt von Kalkar (Fig. 12), shows how an artist still working in the Northern gothic tradition represented the male body. This figure could not be less like either the pagan god Pan, or the classicising image of the same saint by Cima. The arms are pulled up and back in a way which stretches the skin across the saint's rib-cage. Here and there we can see swellings and recesses which suggest muscles beneath the skin, but there is obviously no real understanding of the mechanical workings of the body. For this artist such things were irrelevant. What was important was the clear portrayal of the pain Saint Sebastian was forced to undergo for his faith.

A similar effect may be seen in the remarkable figure of Christ in the *Deposition* (Plate 15) by the Master of the Saint Bartholomew Altarpiece. Here too the arms are pulled back and up, the rib-cage exposed, the limbs stretched and stiff to emphasise Christ's suffering, as if rigor mortis has already begun to fix the limbs in the shape of the Cross.

If we look at some of the other figures in the painting, we can see how the artist has made use of a range of poses and gestures to convey a variety of subtle and intense emotions. The Virgin, on the left, has fainted. Her body is shown sagging into the arms of Saint John, who leans forward to support her. Mary Magdalen leans forward too, her hand to her head in a gesture of despair. The proportions of her body may be anatomically incorrect and totally unclassical but this only serves to emphasise her distress.

This use of the body as a vehicle for the expression of intense or violent emotions was very much a part of the Northern tradition and quite foreign to the classical ideal inherited by Italian artists. Figures of Jesus and the saints were twisted into terrifying positions to provoke feelings of responsibility and remorse in the spectator, and anatomical accuracy was largely irrelevant. The important thing was the dramatic effect.

Poses and Gestures

Actors and dancers have always made use of the dramatic possibilities of movement, stance and gesture. They constantly use their bodies to convey an idea, express an emotion or enhance the meaning of their words. Visual artists, too, have always been aware of the expressive possibilities of pose and gesture. In paintings, just as on the stage, the way a figure stands, sits or moves, may communicate as much to a spectator as any amount of dialogue. The extent to which painters make use of these devices depends very much on the effect they are trying to achieve, and on physical conditions like the size of the painting and its intended position.

The small panel by Duccio (Plate 16) comes from the back of the predella of the artist's *Maestà* – the huge altarpiece executed for the high altar of Siena Cathedral. It would therefore usually have been seen only by the clergy. It shows two scenes from the story of Christ healing the man born blind. On the left we see Jesus raising His hand to touch the blind man's eyes. On the right the beggar appears again, after having washed his face in the Pool of Siloam, giving thanks to God for his miraculous cure.

Duccio's knowledge of anatomy was limited, to say the least, and at first glance the gestures made by the figures of Jesus and the blind beggar may look stilted or wooden, but the clergy would have understood exactly what each movement and gesture was intended to signify. The restrained gesture made by Jesus suggests His power to work miracles effortlessly, and is as eloquent as the more obvious one made by the beggar in thanksgiving.

Johann Liss, a German artist working in the seventeenth century, understood much more about the workings of the body and was able to incorporate that knowledge into his paintings. In his *Judith in the Tent of Holofernes* (Plate 17) the heroine's pose is much more dynamic. Judith was a rich and attractive widow who lived in the Jewish city of Bethulia, which was being besieged by the Assyrian army. She decked herself in her finest clothes and jewels and entered the enemy camp where she was taken to Holofernes, the Assyrian general, under the pretext of having a plan which

would help him defeat the Jews. Holofernes gave a feast in her honour after which he took her to his tent and attempted to seduce her, but he had drunk so much that Judith was able to seize his sword and cut off his head, thereby saving her people and preserving her virtue at the same time.

The ostensible point of the story therefore, is that virtue triumphs over sensuality. Despite this Judith is shown as a rather sexy female. Her shoulder and back are soft and smooth and her backward glance through half-closed eyes is at the same time alluring and derisive.

In Liss's painting the characters perform a mime for the benefit of the spectator. In the painting *"Domine, Quo Vadis?"* (Plate 18) by Annibale Carracci, the figures pose in a kind of *tableau vivant* through which the story is presented very clearly. The figure of Christ is classically proportioned, smooth and muscular, and His gesture directs Saint Peter very clearly back to Rome. Saint Peter's pose expresses his surprise and fear; he is quite literally staggered to see Jesus striding along the Appian Way. The artist made several alterations to this figure before deciding finally on this pose. A preparatory drawing in Munich shows that the saint was originally in a half-kneeling position, and was closer to Jesus, but at some point the figure was made to lean further over to the right, to accentuate Peter's startled reaction.

The saint's reaction is unconscious, a sudden reflex action produced by the shock he has received. The boy in Caravaggio's *Boy Bitten by a Lizard* (Plate 19) is just as shocked and his reaction is just as involuntary, but the contortions of the figure show us more than the boy's pain and surprise. They reveal his naked shoulder and his smooth skin, turning the picture into a very sensual image. The hands are a significant part of the boy's rather melodramatic gesture – the way they are painted, in sharp contrasts of light and shade, makes them stand out and attract the attention of the spectator. This painting may be intended to represent some character from classical mythology but like the many paintings of Venus produced during and after the Renaissance, part of its purpose may well have been to excite. Without a nominal

mythological subject the sensuality of the figure might have seemed even more direct.

The Twentieth Century

In the twentieth century painters and sculptors have produced works of astonishing diversity. Artists such as Kandinsky and Mondrian abandoned content and figurative subject-matter altogether to concentrate instead on colour, texture and abstract formal relationships. It may be that future generations will see the beginnings of abstract painting as this century's most significant artistic development.

However, for those painters and sculptors who have maintained an interest in the human figure the influence of the classical past is difficult to ignore. Even the work of innovators like Picasso is punctuated with traces of classical forms. And the expressive possibilities of pose and gesture have also continued to excite figurative artists. The work of painters such as Delvaux and Balthus shows an awareness of the significance and subtleties of positioning and gesture equal to that of earlier artists.

We could, of course, list a large number of other twentieth-century painters and sculptors for whom the human figure has remained a central motif, but it would be pointless to do so. It is enough to realise that, though it may appear in a variety of surprising and ambiguous contexts, the human figure is very far from being the redundant subject many people must have thought it in the early years of the century.

In this painting Venus epitomises the Italian Renaissance ideal of female beauty, which was based on a revival of the classical ideal. The painted Venus has the form and proportions of an antique sculpture, and stands in the pose of the 'Venus pudica' (Fig. 9). She stands with her weight on one leg, which would tilt her hips, but the artist has unnaturally exaggerated this 'contrapposto' pose, by enlarging the right hip. Unlike the Venus in Cranach's painting (Plate 11), Correggio's nude has no Renaissance trappings and is more completely 'disguised' as a classical goddess.

Although Venus is, as we would expect, an erotic celebration of the female nude, there is an element of charming domesticity about this composition; it presents Venus as Mercury's mistress but also as Cupid's mother. Renaissance humanists interpreted Venus as representing different types of love. For example, she could represent intellectual and spiritual love as well as passionate sensuality. In a painting in the Louvre, probably the pendant to the National Gallery canvas, Venus is shown asleep in an immodest pose, spied on by a lustful satyr; there she probably represents sensual love, and uncontrolled carnal passion.

Correggio was a contemporary of Raphael and worked mainly in Parma in Northern Italy. The National Gallery picture probably dates from the early 1520s and was one of several mythological paintings commissioned by Federigo Gonzaga, Duke of Mantua. It celebrates the classical ideal of beauty and is among the most sensuous paintings of the female nude to have survived from the sixteenth century.

Much of the sensuousness of this painting is due to the way the artist has rendered textures such as hair, flesh and feathers. Correggio made use of a 'painterly' technique, that is, although he made preparatory drawings, he modelled his figures on the canvas by building up superimposed layers of colour, rather than by drawing an outline and filling it in bit by bit. The draperies are painted in subtle shades of blue and dark pink which contrast with and enhance the warm flesh tones of the naked bodies. Often the outlines of the figures are softened and disguised by shadows.

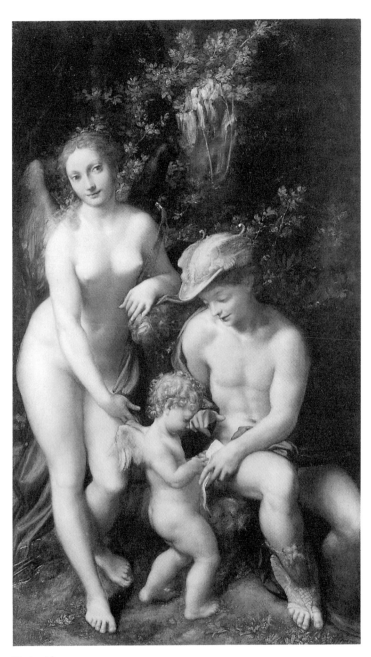

Plate 10

Antonio Allegri da Correggio Active 1514, died 1534
Mercury Instructing Cupid before Venus ('The School of Love')
Oil on canvas, 155.6 × 91.4 cm

A demand for paintings of the female nude can be discerned in Italy from the last quarter of the fifteenth century and in Northern Europe from the beginning of the sixteenth century. Such paintings were often intended to be erotic. Christian iconography provided little opportunity for painting the female nude, but classical mythology provided abundant accounts of pagan goddesses and nymphs who could legitimately be shown without clothes. Giving the picture a mythological title to some extent maintained a necessary degree of respectability.

This painting of Venus, executed around 1530 in Germany, is one of the earliest Northern erotic female nudes. Venus, naked but for her feathered hat and necklaces, looks out of the painting alluringly. It is unlikely that the artist would have used drawings from a live model, and the shape of the figure, with its small waist and high breasts, is still close to the ideal represented in Northern European gothic sculpture. Nevertheless, the contemporary hat and jewellery imply that this is a 'modern' woman who has undressed to play the role of Venus.

Cupid, Venus' son, holds a honeycomb, and complains to his mother about the bees which sting him. The presence of the bees is explained by the Latin verse in the top right corner of the painting; Venus tells Cupid that his arrows of love cause more pain than bee stings. This verse is loosely based on a Greek poem, 'The Honeycomb Stealer' by Theocritus, written in the third century B.C., which had recently been translated into Latin by a scholar from Wittenberg, where Cranach worked. The ancient literary source would have been recognised and enjoyed by the humanist for whom the picture was probably painted.

It is interesting also that the painting uses some of the traditional imagery of the Garden of Eden, such as the apple tree, the lush vegetation and various animals. The female in this garden is both Venus and Eve, who caused man's downfall by her sensuality.

Cranach was employed at the court of the Elector of Saxony and this type of composition seems to have been particularly in demand in court circles. Cranach was the first German artist to produce numerous independent panel paintings of mythological subjects, most of which contained female nudes.

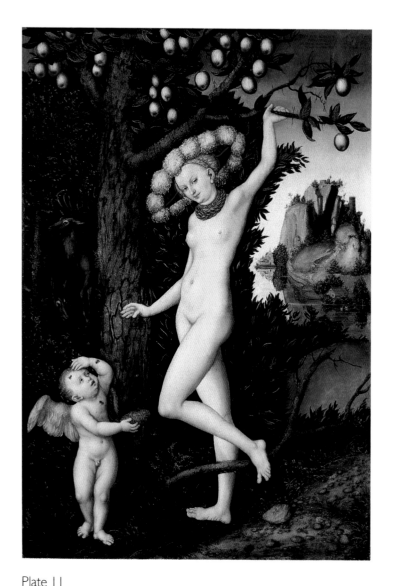

Plate 11

Lucas Cranach the Elder 1472 – 1553
Cupid Complaining to Venus
Oil on wood, 81.3 × 54.6 cm

In Rubens' *Judgment of Paris*, painted around 1635, Mercury instructs Paris, a mortal, to award the prize of a golden apple to the most beautiful goddess— Minerva, Juno or Venus. The goddesses tried to bribe Paris with various gifts; Paris eventually awarded the prize to Venus because she promised him possession of Helen, the most beautiful woman in the world. In Rubens' painting, Minerva stands on the left, Venus in the middle and Juno on the right.

Like many of his predecessors, Rubens was inspired by antique sculpture. These goddesses, for example, stand in the poses of antique Venuses, or perhaps the Three Graces, and the artist has painted them from three different angles so that the viewer is, as it were, shown round a three dimensional figure. In addition, however, he produced large numbers of drawings of the nude, done from life, and in this case it is likely that he used his second wife, Helena Fourment, as a model. He was therefore able to produce figures which referred to the classical ideal but retained a high degree of naturalism.

Rubens' female figures are painted as quintessentially sensual objects. A fur cloak slips over Juno's shoulders and buttocks, while the feathers of the peacock brush her legs. Minerva stretches upwards, langorously displaying herself. We are teased by Venus, who covers herself with a gesture of modesty, having shown her charms only to Paris and not to the spectator.

It is interesting to compare the female figures in the painting with that of Paris, an idealised heroic male, fat-free and athletic, in the classical tradition. It seems less likely that this figure is based on drawings from life.

Rubens probably knew a version of the story told by the Greek writer Lucian, in which Paris asked Mercury to make the goddesses undress, the better to judge their beauty. X-ray photographs reveal that at one stage in the evolution of the painting Cupid was helping Venus to take off her clothes. In the final version the goddesses are naked, but the erotic act of disrobing is suggested by the various items of clothing with which the figures are draped.

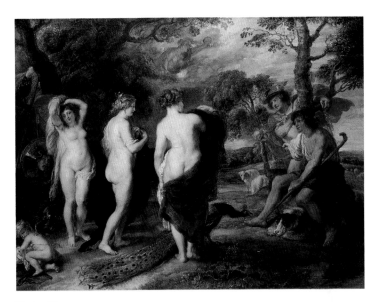

Plate 12
Peter Paul Rubens 1577 – 1640
The Judgment of Paris
Oil on wood, 144.8 × 193.7 cm

The model for this picture, which was painted in 1655, was almost certainly Hendrickje Stoffels, who entered Rembrandt's household in the mid 1640s as housekeeper and became his devoted mistress.

The woman is solidly-built, with legs which are well able to support the weight of the torso. She has taken off her outer garments – we can see them carelessly thrown behind her – and she lifts her slip high above her knees as she wades into the still waters of the pool. The slip is painted in thick strokes of opaque white paint which suggest the texture and weight of the material and the forms of the body over which it is draped. It falls half-way down her shoulder and opens in a wide 'V' to reveal the model's flesh, which, by contrast, is smooth and soft, yet firm.

The painting's directness suggests that it was done from life, and its small scale and its lack of detail or finish, may indicate that it was executed as a study, possibly for a painting of *Susanna and the Elders*.

By the mid 1650s Rembrandt was at the height of his powers. He was completely in command of his technique, and had a knowledge of human anatomy and enough experience of painting the figure to do so with supreme confidence. With a few strokes of the brush, for example, he has managed to describe the hand and the wrist, and indicate the angle at which the joint bends in a way which is completely convincing. It is as if he is using a kind of painterly shorthand, with which he notes down the important shapes, surfaces, planes and textures.

Rembrandt suffered considerable hardship towards the end of his life. He went bankrupt in 1656 and in 1660 Hendrickje and his son Titus formed a company to employ him to make paintings in an attempt to protect him from his creditors. Unfortunately, more suffering was to follow; Hendrickje died in 1663 and Titus, his only surviving child, died five years later, in 1668.

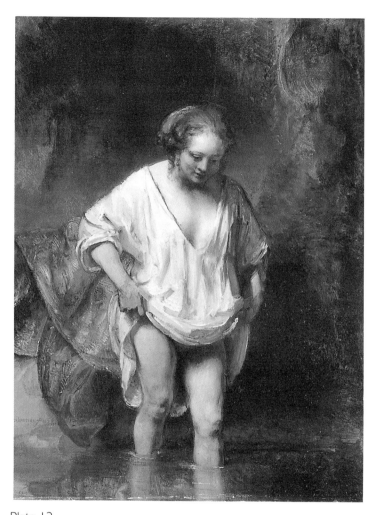

Plate 13
Rembrandt van Rijn 1606 – 1669
A Woman Bathing in a Stream
Oil on wood, 61.8 × 47 cm

The concept of adolescent, ideal beauty illustrated by this painting of Saint Sebastian is ultimately derived from antique sculpture, although Cima was probably inspired by more modern sculpture in Venice by Pietro Lombardo, which was itself a reworking of antique models. The niche setting emphasises the artist's debt to sculpture. In addition, Cima may also have done some drawings from the live model.

Saint Sebastian was an archer in the army of the Roman Emperor Diocletian. Because he was a Christian, his fellow archers were ordered to kill him, but in fact Sebastian escaped death on that occasion. He is shown here in the traditional way, as an idealised, beautiful young man, whose limbs are pierced by arrows but who, nevertheless, shows no sign of pain.

Saint Sebastian was one of the few male figures in Christian art, apart from Christ, who could legitimately be shown naked. There is a significant increase in the number of paintings of him in the second half of the fifteenth century in Italy, that is, during the period when Italian artists were creating a new type of ideal beauty based on antique models.

Traditionally, people prayed to Saint Sebastian during bouts of the plague, a disease to which the inhabitants of Venice were particularly susceptible, and the saint was therefore frequently depicted by Venetian artists. This panel was probably painted in Venice, around 1500. It was acquired by the National Gallery with another of identical size showing a saint, probably Mark, also in a niche. It is likely that the two panels were designed to be part of an altarpiece. They would have been placed on either side of a painted panel, or perhaps a relief sculpture.

Cima was born around 1460 in Conegliano, some forty miles north of Venice. His working life was spent in the city, although many of his commissions came from towns on the 'terrafirma'. Cima's work was particularly suited to pious, devotional imagery, and was popular with religious orders involved in the Catholic reform movement.

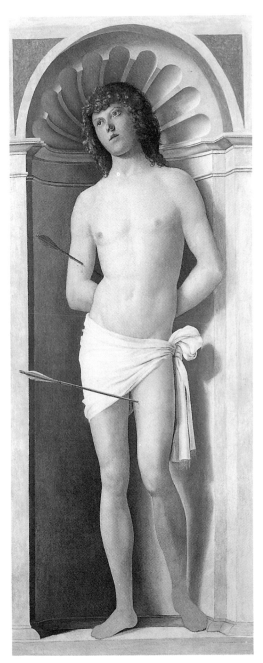

Plate 14

Giovanni Battista Cima da Conegliano 1459/60 (?) – 1517/8

Saint Sebastian

Oil on wood, 103.2 × 40.6 cm

For artists working in Northern Europe the human body was an important vehicle for the expression of emotion. In some cases, even the type of body the artist chose to depict was significant. In the *Deposition* by the Master of the Saint Bartholomew Altarpiece, the physical types contribute to the expression of an emotion which is intense and disturbing.

The body of Christ is the focal point of the composition, but this is not the idealised heroic figure we see in the painting by Carracci (Plate 18), but the broken tortured Christ of the time immediately after His death. Though He has been taken down from the Cross His shoulders and rib-cage remain distorted, as if rigor mortis has already begun to stiffen His body. This unidealised figure expresses very clearly the pain and despair of the Crucifixion.

The other figures display their feelings in various ways. Mary Magdalen leans forward and holds her head in her hand in a gesture of despair. The figure behind her looks piously upon the Crown of Thorns, her cheeks wet with tears, while the woman on the left looks up at the figure of Christ, and joins her hands in prayer.

But the most ambitious figure in the painting is the one at the top. He leans forward, bent double, with only one foot on the ladder, holding on to the Cross with one hand and to Christ's right arm with the other. We can see the veins standing out in his wrist from the effort of supporting the heavy dead body. His right leg is extended behind him and his toes are hooked over the arm of the Cross to stop himself from falling. This foreshortened pose may be difficult to 'read' but it expresses perfectly the figure's precarious balance.

This painting may have been the centre panel of a triptych made around 1505. The peripheral decorations suggest the decorative woodwork on a carved retable. Another painting by the same artist is reproduced as Plate 4.

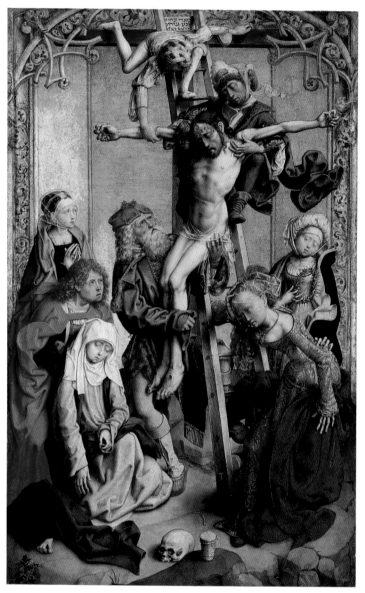

Plate 15

Master of the Saint Bartholomew Altarpiece
Active late 15th/early 16th century
Deposition
Oil on wood, 74.9 × 47.3 cm

In the late Middle Ages, paintings were often designed to convey messages to the illiterate or to direct the attention of a church congregation. To do this successfully their meaning had to be clear and easy to understand. The movements made by the figures with which an artist peopled his paintings had to be equally clear and unmistakable.

The gestures made by the figures in Duccio's small panel, which illustrates a scene from the Ministry of Christ, indicate precisely what is happening and convey some of the drama of the miraculous event. In the absence of words their poses and gestures take on a vital importance. The figures stand along the bottom edge of the painting, very much in the foreground. The Disciples crowd together behind Jesus, pressing against each other to see what He is up to, as if they know that something remarkable is about to happen. Jesus Himself leans forward slightly, His left hand raised in a gesture of power or authority. His right arm is stretched out, and the index finger is extended towards the man's eyes to cure his blindness.

The blind man leans on his staff, his knees slightly bent, his shoulders hunched just a little, one arm raised in the direction of his face. He can feel the touch of Christ's finger and the cold grittiness of the paste with which his eyes are being anointed, and his whole body is poised in anticipation.

Duccio was the greatest artist of the Sienese school of painting in the thirteenth and early fourteenth centuries. In 1308 he was commissioned to paint an enormous altarpiece for the high altar of Siena Cathedral – the *Maestà*. It was carried in procession through the streets of the town and put in place above the altar three years later, in 1311, and is now housed in the cathedral museum. The main panel depicts the *Virgin and Child Enthroned with Saints and Angels*, but the predella, that is the structure at the bottom of the altarpiece which supported the rest of the work, was decorated with panels depicting scenes from the Life and Ministry of Christ.

This small panel comes from the back of the predella, and would usually have been seen only by the clergy, who would have understood the significance of every pose and gesture.

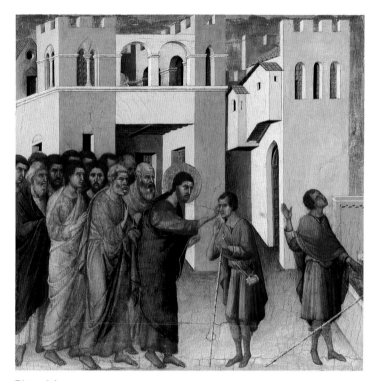

Plate 16

Duccio Active 1278, died 1319
Jesus opens the Eyes of a Man born Blind
Tempera on wood, 43.2 × 45.1 cm

Judith's dynamic pose occupies most of the canvas. The sweep of her arm across the decapitated body of Holofernes catches the light and reveals her muscular yet sensuous naked back. She turns her head back and looks at the spectator with an expression which contains a mixture of disgust and allure. Holofernes is stripped to below the waist to show off the well-developed muscles of the physically fit fighting man. Nevertheless, despite his strength, the Assyrian leader succumbed to his own physical desires.

This story comes from the *Apocrypha*, that is, the part of the Old Testament which was included in the Protestant Bible after the Reformation, but which was not accepted as being an original part of the Hebrew Scriptures by the Jews.

Judith lived in the Jewish city of Bethulia which was being besieged by the Assyrian army under the leadership of the general Holofernes. Just as the inhabitants of the city were near to capitulating Judith devised a plan to save her people. She dressed herself in her finest clothes and jewels and entered the Assyrian camp, where she pretended that she knew of a way of defeating the Jews. Holofernes gave a great banquet after which he took Judith back to his tent and attempted to seduce her. But, having drunk too much during the evening, he was unprepared for Judith's violent attack. She cut off his head, placed it in a sack, and escaped back to Bethulia. When they discovered their leader was dead, the Assyrians fell into disarray and fled.

This story of female virtue triumphing over male lust was often painted as a pendant to depictions of Samson and Delilah, which, of course, tells of male virtue succcumbing to female guile.

Liss was a German painter, who may have trained in the Netherlands. His presence in Venice is recorded in 1621 and his career seems to have been spent in Italy. This painting probably dates from around 1622.

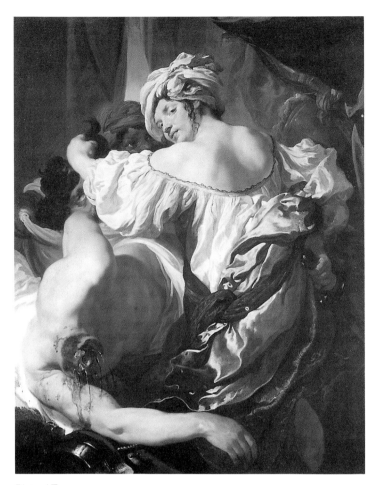

Plate 17
Johann Liss About 1595 – 1629/30
Judith in the Tent of Holofernes
Oil on canvas, 128.6 × 99.1 cm

During the seventeenth century artists who worked within the classical tradition were often anxious to demonstrate their knowledge of antique forms by quoting from famous statues of the past in their paintings. In this panel by Annibale Carracci, painted in 1601/2, the pose of the figure of Christ resembles that of the *Borghese Warrior*, a Hellenistic statue, which Annibale may have known through Roman copies. The only major difference is that in the painting the pose is reversed. This tradition of re-using tried, and therefore trusted, models continued until well into the nineteenth century.

The story illustrated is not very commonly represented in paintings. According to legend Saint Peter was fleeing from Rome and the persecutions of the Emperor Nero, when, just outside the city gates he had a vision of Jesus carrying the Cross. Saint Peter was understandably startled by this apparition and asked Jesus where He was going. Jesus replied: "I go to Rome to be crucified anew". Whereupon Saint Peter said that he too would return to Rome and be crucified like his Master. At this point the vision vanished. Peter did return to the city, was arrested and eventually crucified, upside down.

The painting shows Christ walking towards us through the Roman countryside. His body is classically proportioned, smooth and muscular. It bears the marks of the nails and of the Roman's spear but aside from these details – which are in any case understated – it shows no sign of the appalling battering it received before and during the Crucifixion. Instead it is graceful and idealised like the body of a classical athlete. In Annibale's painting Christ is triumphant; He has conquered the pain and shame of His Passion and Death. By contrast, Saint Peter is shown leaning backwards, his hands raised to his head in a gesture which expresses the all too human emotions of surprise and fear.

Annibale Carracci was one of a family of painters from Bologna who established an informal academy in which great emphasis was placed on the value of classical models and the importance of drawing constantly from the live figure.

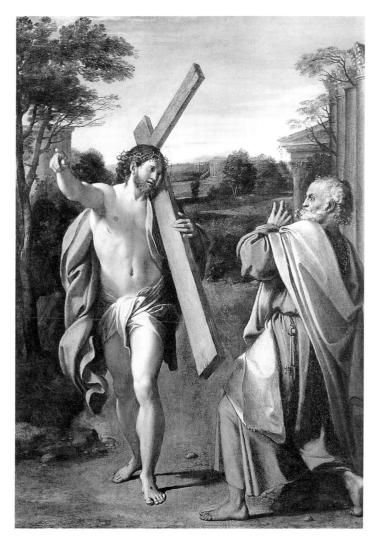

Plate 18

Annibale Carracci 1560 – 1609
Christ Appearing to Saint Peter on the Appian Way
("Domine, Quo Vadis?")
Oil on wood, 77.4 × 56.3 cm

The artist has painted this figure for the most part against the light, and this contrast of bright highlights and dark shadows emphasises the drama, or rather melodrama, of the event.

The boy has just been bitten by a tiny green lizard lurking, hidden, amongst the fruit on the table and is shown flinching in pain and surprise. His reaction is natural and we can sympathise with it. The thought of the lizard's sharp teeth puncturing the fleshy tip of his finger is enough to send shivers down the most insensitive spine. His shoulder is raised as he tries to withdraw his hand quickly, and he twists his body in an attempt to shake off the insistent little reptile.

The painter is very obviously concerned with the description of physical sensations. In addition to the pain of the lizard-bite we are shown the boy's naked shoulder and smooth skin, and the flower in his hair suggests that he is not entirely unaware of his own sensuality.

Caravaggio was famous – in fact during his lifetime he was infamous – for working directly from the model, painting straight onto the canvas rather than working-up the composition in a series of preparatory drawings. This practice was thought by some critics to be sloppy and unprofessional, but it allowed him to produce paintings which have a freshness and spontaneity not to be found in the work of any other artist of the period.

A great deal has been written about Caravaggio's presumed homosexuality and many of his paintings, particularly early ones like this, certainly seem to have a homo-erotic flavour. This painting may be one of those the artist painted in the early 1590s for patrons like the Cardinal del Monte, who were attracted by smooth-skinned adolescent boys, and who would have appreciated the painting's sensuality.

Many of Caravaggio's paintings of this period are vaguely mythological or allegorical; they represent the God of Wine or the pleasures of the senses, and the mythological disguise gives the pictures at least an air of respectability. However, this painting, though almost certainly intended as erotic, may be more about the pain of love than its pleasures.

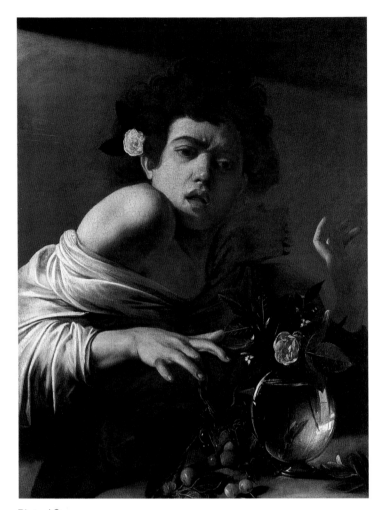

Plate 19

Michelangelo Merisi da Caravaggio 1573 – 1610

Boy Bitten by a Lizard

Oil on canvas, 66 × 49.5 cm

FURTHER READING

The idea of the changing pattern or schema discussed in Part I is a major theme in *Art and Illusion*, by E. H. Gombrich (Phaidon, 5th edition, 1977). Cennino Cennini's *Il Libro dell'Arte* has been translated by Daniel Thompson as *The Craftsman's Handbook* (Dover, 1960), and Alberti's treatise *Della Pittura* has been translated by J. R. Spencer as *On Painting* (Yale, 1966). An important essay on the proportions of the figure by Erwin Panofsky, 'The history of the theory of human proportions as a reflection of the history of style', was republished in Panofsky's *Meaning in the Visual Arts* (Penguin, 1970).

LIST OF PLATES

ACKNOWLEDGEMENTS

The authors are very grateful to their colleagues in the Education Department for their assistance and support, and in particular to Alistair Smith for his constant encouragement and invaluable advice throughout the organisation of the exhibition and in the writing of this book. We would also like to thank Paul Hannah and Vassoula Vasiliou who designed the exhibition and the book, Margaret Stewart, Jacqui McComish, Carol MacFadyen, Eric Arnold and the staff of the Photographic Section. Outside the building our thanks are due to Malcolm Baker of the Victoria and Albert Museum, Paul Goldman and Hilary Williams at the Print Room of the British Museum, Godfrey Evans of the Royal Museum of Scotland, Jane Roberts at Windsor Castle and Helen Valentine at the Royal Academy.

For permission to reproduce, grateful acknowledgement is made to: Her Majesty the Queen (Fig. 2) © Windsor Castle, Royal Library, The Trustees of the British Museum (Figs. 3, 4, 5, 6, 9 and 11), The Trustees of the Victoria and Albert Museum (Fig. 10), The Visitors of the Ashmolean Museum (Fig. 1), Musées Nationaux, Paris (Fig. 8), The Royal Academy of Arts, (Fig 7), The Trustees of the National Museums of Scotland (Fig. 12).

Exhibition and Book designed by
Vassoula Vasiliou and Paul Hannah
The National Gallery Design Studio

Printed by W.S. Cowell Limited, Great Britain
National Gallery Publications
The National Gallery, London

Front cover: details from *The Judgment of Paris* by
Rubens (left), *A Woman Bathing in a Stream* by
Rembrandt (centre) and *General Sir Banastre Tarleton*
by Reynolds (right)